IMAGINARY VESSELS

PAISLEY REKDAL

IMAGINARY VESSELS

COPPER CANYON PRESS

PORT TOWNSEND, WASHINGTON

Cover art: Frederici Ruischii, from *Thesaurus animalium primus : cum figuris aeneis,* published 1710.

Copper Canyon Press is in residence at Fort Worden State Park in Port Townsend, Washington, under the auspices of Centrum. Centrum is a gathering place for artists and creative thinkers from around the world, students of all ages and backgrounds, and audiences seeking extraordinary cultural enrichment.

LIBRARY OF CONGRESS CATALOGING-IN-PUBLICATION DATA

Name: Rekdal, Paisley, author.
Title: Imaginary vessels / Paisley Rekdal.
Description: Port Townsend, Washington : Copper Canyon Press, [2016]
Identifiers: LCCN 2016019489 | ISBN 9781556594977 (paperback)
Subjects: | BISAC: POETRY / American / Asian American. |
PHOTOGRAPHY /
 Photoessays & Documentaries.
Classification: LCC PS3568.E54 A6 2016 | DDC 811/.54—dc23
LC record available at https://lccn.loc.gov/2016019489

98765432 FIRST PRINTING

Copper Canyon Press
Post Office Box 271
Port Townsend, Washington 98368
www.coppercanyonpress.org

ACKNOWLEDGMENTS

North American Review: "Mae West: Advice," "Philip Larkin's Koan"; *At Length:* poems of the "Shooting the Skulls" section; *Connotation Press:* "Letter from the Pribilofs"; *Diode:* "The History of Paisley"; *The Journal:* "Irises"; *Kenyon Review:* "Assemblage of Ruined Plane Parts...," "Mortal Love," "A Peacock in a Cage"; *The Literary Review:* "Once"; *The Missouri Review Online:* "Portrait of F19: Male, 42 Years Old (as "C4: male, 39 years old")"; *Narrative:* "Baucis and Philemon"; *New England Review:* "Birthday Poem," "Saturdays at Reynolds Work Release," "When It Is Over, It Will Be Over"; *The New Republic:* "Murano"; *Ninth Letter:* "Confessional," "Freedom," "Go West," "Marriage," "Never," "The New Woman," "You're"; *Poetry:* "At the Fishhouses," "Vessels"; *Poetry Northwest:* "Rhetoric"; *South Dakota Review:* "Olive Oatman in Texas"; *Water~Stone:* "Bubbles"; *Willow Springs:* "W.C. Fields Takes a Walk."

"Self-Portrait as Mae West One-Liner" was published on the Academy of American Poets' "Poem Flow" for its Poem-A-Day project.

"Birthday Poem" was reprinted in *Best American Poetry 2013*, edited by Denise Duhamel.

"W.C. Fields Takes a Walk" was reprinted in *Pushcart Prize XXXVII: Best of the Small Presses.*

"Monticello Vase" appeared in the anthology *Monticello in Mind: Fifty Contemporary Poems on Jefferson,* edited by Lisa Russ Spaar, University of Virginia Press.

"Vessels" was reprinted on the Poetry Daily website.

Thanks to the Amy Lowell Poetry Travelling Scholarship, the University of North Texas for its Rilke Prize, the Guggenheim Foundation, the Jentel Foundation, and the University of Utah for support. Thanks to Lisa Bickmore, Susan Brown, Kim Johnson, Natasha Sajé, Susan Sample, Melanie Rae Thon, and Jennifer Tonge. A special thanks to the editors who made these poems better, especially Jonathan Farmer, Tonaya Craft, and Michael Wiegers, and all the fine people at Copper Canyon Press.

Finally, my deepest gratitude goes out to Andrea Modica for use of her images, previously published in *Human Being* (Nazraeli Press, 2001).

FOR MY FRIENDS

You think you do well to hide the little things in the big ones—
but what if you were to hide the world in the world?

Chuang Tzu

We are truly ourselves only when we coincide with nothing,
not even ourselves.

E.M. Cioran

CONTENTS

I

II GO WEST

III

IMAGINARY VESSELS

I

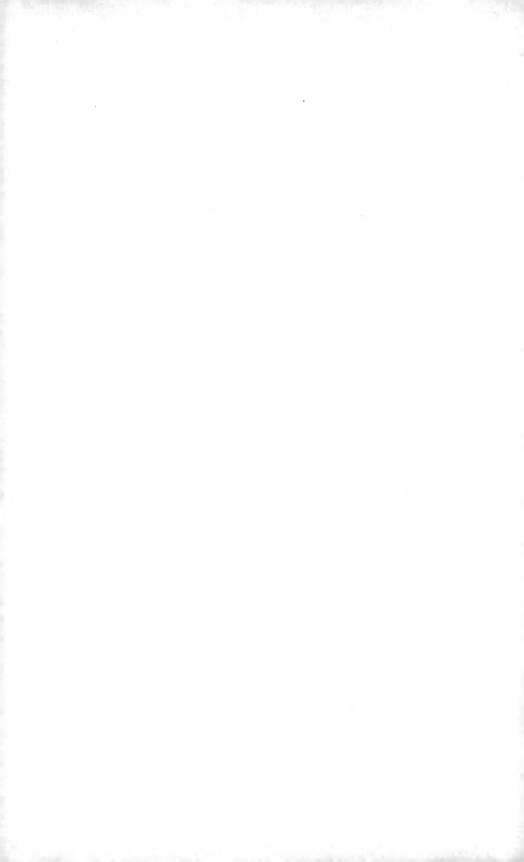

It is not miraculous. Only a handful of silica, fire,
and then the blower twirls another knob of gold
on his metal pontil, dipping the tip into a pot
inlaid with spikes to make the burning globe
twist in upon itself as the man breathes out
and a thin neck bulges, wreathes into a spiral
like a unicorn horn; but we're bored, he's
bored, blowing and blowing the same shape over.
It takes no effort. He stares off through one
of the factory windows as he does it, beneath a sign,
No Flash, a red line drawn through a cartoon camera
to indicate the work is private, dangerous.
The man's tongs pinch out a chest, a neck, the crowd
applauding each development though it has seen
the same thing around the corner.
We know what will come next. The man
reaches into the bright elastic to yank
a fat neck forward, to pinch out hair, a shovel-
shaped face; to pull out one thin, bent leg
and then another, the glass itself now tinged with ash
as the fire runs out of it, dimming to topaz,
caramel. He splashes water on the irons
to make them smoke. It must be dangerous, this
material, or why else would we watch?
The blower has a bald patch, earrings, scars.
He dips his tongs once more into the figure
and out come back legs, a tail. The neck twists
and now the little face has a mouth that's open,
screaming. Transparent hooves tear into the air.
The tail's curled filament starts to thread
as the pontil pulls away. You want to say

"like taffy," but don't. It is not sweet.
Only a spark of heat and then the inevitable
descending numbness. Someone laughs.
Someone takes a photo. For a moment, the room
fills with light behind which we hear
the scissor's dulling snap.
Our senses return stretched thinner, fine.
We can almost feel the shattering of the glass.

BUBBLES

The child purses his lips around a hole. Blows

and out the radiant world swells forth.
The park swings bend. His mother's face shrinks

to the size of a bubble. I sit across from them,
on my separate bench, bobbing past in its reflection.

It's my gift, this vial of soap.

I bow my dark head low as my friend's son
pats my cheeks in thanks, obediently
sucks in another breath

and blows.

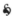

 "Any fool can make soap;
it takes a clever man to sell it."
So Thomas Barratt, 1880, said, and pursued Millais
to paint Pears' advertising: an English painter

for an English soap. "Of two countries
with an equal weight of population," he wrote,
"the most highly civilized will consume

the greatest weight of soap." A quote
from my scholar friend in her book
on bubbles that she's given me: my gift
of this toy a nod to her descriptions

of palm oils rendered in chains
of vats, thickened with the meat
of African coconuts.

 Through a stream of bubbles,
I watch her wipe her son's streaked face, recall
my washing machine at home which has a setting

labeled Baby Clothes. The store model
wore a pink-and-blue sign reading,
Don't You Want One? I think

of the painting on her book's cover, *Newton's
Discovery of the Refraction of Light:* a thin-faced scientist slumped
in dark, while his nephew, by a bank of windows,
blows bubbles. On Newton's side of the canvas:

a dusty globe, a world of shadows
that dissolves beside the child
in play, revealing how the sun refracts the panes
the maid will have to scrub. In the image,

she turns her head away, the sun
begun to bore into her eyes. And here's a bore of sun
illuminating the bubble's flaw that stuns the child

now blowing in the park, learning the tensile skins
can't withstand the pressure
of a touch. "They don't last!" he shrieks

as his mother hugs him, a squalling
aggregate of cells neither of us can hush. Of cells,

I also thought *an aggravate.* "Make this the sweetest

picture postcard yet," Barratt begged Millais. And so
the painter drew a Pre-Raphaelite child at play
blinking at the globe he's made, a lens of clean in which

the thin white etch of him sails past
in dark, the milk-white cheek, the booted
foot: the boy's blue eyes turned in rapture to what

a parent's invention makes. *A Child's World,*
Millais titled it, but Barratt
stuck a bar of Pears in it and turned

the painting into posters, puzzles, postcards
shipped along with images of English flags
and Maori girls, kaleidoscopic
slow flash photos of bursting
bullets, their shock waves caught and used to improve
British rifle manufacturing.

 "We have a perfect right
to take toys and make them into philosophy,"
my friend's book quotes. "Inasmuch as we have turned
philosophy into toys."

Look: a bubble of black
wobbles and bursts: explodes the world
to a slick of oil.

The clouds pull back. The boy, damp faced from his fit,
now sleeps. Sunlight holds, refracts him in his nap
as something in my friend's face

cracks. It wildly opens.

Don't you want one? something whispers. *Don't you, really?*

 Last night's thinnest edge
of dream still wavers, the one where the doctor tells me
I am carrying, but will not tell me what
or when. Black hope rises,
bursts inside me. "It's an aggravate of sells," he says—

The world grows thin. My friend packs up the toys and kit,
tapping at her soapy vial.

She shakes up the foam and sticks in the pipe.
A world blows up.

The mother and child float by in it.

VESSELS

Shouldn't it ache, this slit
into the sweet
and salt mix of waters

composing the mussel,
its labial meats
winged open: yellow-

fleshed, black and gray
around the tough
adductor? It hurts

to imagine it, regardless
of the harvester's
denials, swiveling

his knife to make
the incision: one
dull cyst nicked

from the oyster's
mantle—its thread of red
gland no bigger

than a seed
of trout roe—pressed
inside this mussel's

tendered flesh.
Both hosts eased
open with a knife

(as if anything
could be said to be eased
with a knife):

so that one pearl
after another can be
harvested, polished,

added to others
until a single rope is strung
on silk. Linked

by what you think
is pain. Nothing
could be so roughly

handled and yet feel
so little, your pity
turned into part of this

production: you
with your small,
four-chambered heart,

shyness, hungers, envy: what
in you could be so precious
you would cleave

another to keep it
close? Imagine
the weeks it takes to wind

nacre over the red
seed placed at another
heart's mantle. The mussel

become what no one
wants to:
vessel, caisson, wounded

into making us
the thing we want
to call beautiful.

shaking out its corona of tail feathers is like light
glowing in a bulb, a man
dancing inside an elevator: the space
too small to quite contain him, yet
contain him it does; the way a cloud
keeps some portion of the sea inside it or a box
encloses air, encloses also
the philosophical cat both dead and alive
inside it. The way a car inhales the gas
containing bones of dissolved dinosaurs
and the cheese breeds mold to heal the cut that holds
the hurt cradled inside the body, the blood
thick with the trace of all things
we might yet express or become, such as
the mathlete or music lover, who holds first
one note and then the next inside her ear.
We try to pin the mind's attention to the task at hand
though the mind can sometimes falter, the way
a tongue sometimes cannot rein in the word
whose meaning may escape it, may be captured
so perfectly within its syllables for once
the desire/the surprise/the distaste churn
palpably when uttered; just as the parent's past churns
inside the child's future or the identity of the stranger
hides inside the mundane title with which
we greet him. There are lies we clasp to ourselves
upon waking, truths with which we worry
ourselves to sleep, dreams memory struggles
to capture in the retelling: only the ends remain
in which the building crumbles back to dust
or the mother steps, naked, out of her unzipped skirt:

an image that bears the seed of future therapy.
One book contains at least a dozen others, the scarlet
bitterness of its pith conceals the sweetness
of the mangosteen and, when saddest, we suspect everyone
embraces someone else, though many don't.
We think a woman shelters a house, husband and a child
inside her, that a man might accommodate
no one else. The party can hold its liquor
only so long, as we can maintain faith that requires us
to keep two contradictions alive at once, like day
and night tucked into the same sunset or the sudden
hatreds ignited by love: the patience
with which we hold still for the camera, believing
it will shore up time, and knowing it won't.

And the black water under the boats with their pools
of bilge rainbowed out like rinds
of steak fat, the salt thick
in my nostrils, but pleasant, too: details
I still keep from Bishop's poem, everything
else about it lost. At the docks,
I watched my friend slip
in her rubber boots; the wide, wet planks
glossy with mosses. You must walk
duck-footed to get to the boats, the black-and-orange
fishing barrels, the air with its tang
of rust and blood. There are always hooks
and anchors to be found here, nets and scrapings
of wood planed by chisel, the way
my great-grandmother was said
to have worked, employed as a shipwright
on the city's waterways in the '30s, according
to the newspaper clipping my grandmother
photocopied for me each Christmas.
The description of her gunmetal hair
and slim torso clad in overalls, the hands
she held out for the *Times* reporter
("Callused," he noted, "strong
as a man's"), does not recall the woman
I remember for her farm in Bothell
before it became a Seattle suburb, helping me gather
raspberries from the long canes
she planted by her porch. We spent an afternoon
together sweating in the matching
long-sleeved checkered shirts she'd made us,
according to the photo

I no longer have, and cannot remember
whether is the source or confirmation
of this memory. Only the papery, gray-green
streaks of road dust on the canes, a bowl
of chipped porcelain inside of which
were raspberries. Very red, very sweet, furred
like my friend's upper lip I remember
between my teeth as we stood
on the docks. The smell
of iron and winter mist, her mouth
like nothing I have tasted since.

WHEN IT IS OVER, IT WILL BE OVER

pen and ink reproduction by Troy Passey of a line by
Edna St. Vincent Millay

Hurricane of what must be
 only feeling, the painting's
sentence circling to black

on blank, ever-
 tightening spiral
of words collapsing

to their true gesture: meaning
 what we read
when not reading,

as the canvas buckles
 in the damp: freckled
like the someone

I once left sleeping
 in a hotel room to swim
the coast's cold shoals, fine veils

of sand kicked up by waves where
 I found myself enclosed
in light: sudden: bright

tunnel of minnows
 like scatterings of
diamond, seed pearl whorled

in the same
 thoughtless thought
around me: one column of scale

turning at a moment's decision,
 a gesture I
was inside or out

of, not touching but
 moving in
accord with them: they

would not wait for me, thickening
 then breaking apart as I slid
inside, reading me

for threat or flight by the lift
 of my arm, as all
they needed to know

of me was in the movement:
 as all this sentence
breaks down to O's and I's,

the remnants of someone's
 desires or mine so that
no matter whether I return

to that cold coast, they will
 never be there: the minnows
in their bright spiraling

first through sight, then
 through memory,
the barest

shudderings of sense:
 O and *I*
parting the mouth with a cry

that contains—
 but doesn't need—
any meaning.

LETTER FROM THE PRIBILOFS

Elizabeth Beaman to her sister,
Pribilof Islands, July 13, 1880

Blunt, bullying, this season's bachelors climb
the rocks near Nah Speel, sleek backs blackening
the waters inside their seacatchy. The old
bulls line up in rows as at a burlesque
house, while their matkas roll in surf, thrash
upon the parade ground's volcanic sands
turned glassy from the constant passing of seals.
One by one the bulls slip the line to claim
their females, each dragging his choice to a private
catch, as the bull gathers what he can,
the matka cuffed and bitten on the throat
if she struggles, the bull shaking her, banging
her down upon the rock until she rolls
her belly up, blank eyes wet in supplication.
This is how I imagine it. The event being
"no sight a lady should witness," the Senior
Agent forbids me from the rookeries; John,
my husband now these thirteen months,
must privately describe it. *Libby,* he tells me,
you should see how soulful they are, it is
amazing to watch them weep. He takes joy
in their human qualities, recalls tales
of selkies who turned to seal-like girls
in surf, braiding their hair in seaweed plaits
to chain an errant sailor's legs. And yet,
in seasons such as this he goes out with company
men to kill the mating seals in their rookeries,
drive them to ground with wooden clubs.

I've heard the sounds and smelled grease fires
smoking after skins are flensed, seen John
creep back from work, clothes spattered with blood.
How many months to be endured! And all before winter
comes, its long months unpunctuated by sun—
And yet I can't complain, having begged John
to take me, a lone white woman at these edges
of the Pribilofs. Reluctant first, he is, I think,
now proud of me. Without a maid, John is the one
to tighten my stays, fetch me
paper, drawing pencils, tea. When he's gone
I walk as far as the officers will let me,
to sketch a little of the matkas and their young.
Yesterday, a shape disturbed me
at the game: some wraith shadowing
Nah Speel's rocks I noticed late, absorbed
by the sight of two bulls hissing and spitting
at each other, while a third made off
with the spoil they longed for: the matka
flattened on the glassy ground. *Interesting,
isn't it, Elizabeth?* the wraith addressed me.
I looked. It was the Senior Agent—
He is, as I wrote before, the dark one
who follows me on my rounds, complaining
of my presence here. He charts my walks
around the island; once, in the mess hall
pinched my arm in passing, hissing, *Selfish
to remain*—
 At home I raged at John,
who shook his head, but will say nothing.
How can it be selfish to claim my rights
beside the one I love? A loud groan, the sea's
kaboom, and one of the bulls, his shoulder
pierced deeply, struggled off.

I watched his slow creep back into the sea,
his shape dissolving inside a curl of blood.
When I looked up, the Senior Agent was gone.
Tonight, I send along a sketch I've done
of a bull with his sleek matka, half-drawn,
only the heads and eyes completely finished, that
peculiar quality to their gaze I struggle
to capture: that clear, yet fathomless unblinking
from which occasionally come—to John's
continued astonishment—real tears.

II

GO WEST

Diamond Lil is all mine. I'm she. She's I. Like Hamlet, but funnier.

Mae West

[Her language] isn't clever dirt, and it isn't really at all shocking—but it's the kind women want, apparently. Women are simple souls.

Jim Timony, Mae West's manager

YOU'RE

Your hands your lips your hair your magnificent effervescence—

Vague as fog and turnip-hipped, a creel of eels
that slithers in stains. Dirty slate, you're
Diamond Lil. She's you, you say. You're her. She's I. O
Mae, fifth grade, we dressed in feathers and our mothers' slit
pink slips, dipped into your schema and your accent,
aspiring (like you) to be able to order coffee and have it
sound like filth. And yet aspired to whom? Amazing
all these films and each cow-eyed character the same:
Catherine the Great, Margie LeMont, Peaches O'Day. I
grant, I never saw a single goddess go but you
rewrote her into you. Each maid a moon
orbiting your Mae. And she the same star always winking,
flaring out rotational names: Cave Girl, Sis, Tira, Fifi—
What're you doin' honey, makin' love or takin' inventory?

Ban tobacco: do bacon abed,
be delectable, collectible, a decent debacle.
Décolleté don't conceal; acne, do. Be bold
and be toned, an octane-blond coed.
Be colonel not cadet, concede nada to doc;
date a cad and canoodle, be éclat on a cot.
Don't lean on a deacon, be a dolt, a clone:
don't bet on an Eden, don't loot, don't loan—

Be belle and ball, too, a deb Coco-labeled;
be ocelot, be lancet, be candle and cabled.
Canceled? Debated? Booed at to boot?
Elect to be tall. Don't tan. Eat local.
Be oded, caboodled, be beacon and lect.
Don't be a noodle: be cool and collect.

MARRIAGE

Any dame that knows the ropes won't get tied up.

Mae knows wit's a waste on those who think
a woman is a sink of mind. Smart dames
edit out the spouse: rather get sent to Sing Sing
than tied in knots. A dame should take her own name.
She did. Tho ain't that name turned into sign, her shape a stage
that's trope? Rigid iteration, she smirked the same
at eighty as nineteen: a drawling monster roped
to her own shade. She's a playwright. She's a genre. "A woman
among men," is what Mae said. "I'm new." Then wrote
The Drag. Mae, did you get our unsure titters at the end?
Did you get you turned to gag? Prostitution's
a more honest gig, you wrote, of marriage and the page.
And now your theaters stand dark. You got it right, it seems.
Hamunaptra, Dirt-Lip, Wag: everyone hates an institution.

CENSORED

I always believed in censorship: I made a fortune out of it.

Dalí nails Miss Bawdy: cave of lip-shaped couch and starry
eyes, a room dilated to empty: velvet space
in which a *lotta hussy nothin'* floats, so writes
Variety of vaudeville's paints that obsidian a face
moon-pale, shuttered to history—

 Mae sends her maid Bea west
to Harlem where she cannot travel
to procure her tunes (Piano man croons: "He may be your man
but he comes up to see me sometimes"; "That'll do," Bea says) while
on the boards Mae nips out bits
of bio (spouse and birthday both), turns her script to crypt-
ic lace as police haul her off
for indecency. ("My play?" she purrs. "Let's call it
'Coitus,' shall we?")

 In the courts and on the boards, Mae sways
and shimmies. Bea, from her place
behind curtains, applauds
as Mae's mouth spits out bursts
of Bessie Smith, Lady Day, Ma Rainey.
Mae loves Bea so much she writes her
into play (Diamond to Maid: "Lissen, shadow,
whad're you doin' here?"), laughs at the thought
only one letter between them separates.

 Dalí's canvas is a frame
within a frame, portrait of a face for which
the outline is enough. She's a sofa now. An oriflamme. Her eye
discourses. Hey, what's that dark that breaks
through yonder window?

Court: So did you ever see her navel?
Witness: No, but I did see somethin' in her
middle travel east to west.

FREEDOM

He's the kind of man a woman would have to marry to get rid of.

Mae: once, a man wrestled me to ground, wrangled my hands in his
and, when I tried to knee him in the groin (missed),
yanked my legs from under so I wouldn't run. He laughed
as I saw stars. I get it: freedom (for a woman) has
a tag on it: ya gotta have more strength at hand, ya gotta have
no fear of fists. *Give a man a free hand, he'll run it all over you.*
Gag whose strut of which I'm envious; of you, who thrived
on hungers without risk. Should I praise or blame these plays
no girl's reality might imitate? Not even yours, feinting
off a drunken Fields, Yale men aswarm upon your stage—
To slide on your armor means to fake
away what hurts. The one who, instead of kiss, would shove.
The one who, gently, strangled. Mae, we weren't swift
enough to rid ourselves of them. We were never swift enough.

GO WEST

"Mae West": British slang in WWII for inflatable life jackets

some women

gat slug black

at home and marry

some women watch

Emma Gee, sweet Fanny

may pucker up

buck ship at home

club, sweet johnson

some women fancy

get cold feet, get glory

Emma Gee whistling

cold gat slug

some women ace

pick men to marry

jack johnson

some men ache

your six, ace,

men glory

some isolate

in pieces

top or bottom in flames

hitchy

saxes, ace, inflamed

at home

watch isolates

pucker up, Mae

some pieces

Panzer pipped

patter of moan

Audrey's top & bottom

inflame home ache

grow cold

Jack or Billy

some men are bucked

hole moaning

club johnsons

picked

some men get sixed

pick 'em to pieces

THE NEW WOMAN

*I like a man who's good but not too good—for the good die
young and I hate a dead one.*

Belle of the Nineties, bid good
riddance to old glad rags. Get Gold
Bond, Horlicks, Good-Gal, Twilfit. *Good
Housekeeping* says we are flesh
that hungers for the goods. Don't
begrudge yourself. Goodness,
why bother? Lo, the Good
Lord knows a man
must work. And a good man works,
Mae says. At least on me.
Until such goodness
kills him. We all die
anyways. So long. Boo hoo.
A hard man is good to find,
Mae says. A hard woman, too.

MAE WEST: ON AGING

I'm telling you, it's always better to be looked over, than
overlooked.

Better your mask in the mirror. Better yet,
mask the mirror. Listen to Auntie Mae: It's better
to evoke drool, to banter than ebb, better to be boned
than bones. A woman is time's slave and intimate, lost
the moment her looks begin to go. You like your skin

as it wilts and slides, relieved by your total release
into time's dominion? No more babe in woods, you say,
you're Astute Botanist; Noisome Hetero Drone evolved
to sanguine witness. The soul, meat's subtle shadow,

has no looks at all. So why not enshrine
what ornament skin gives it: thank the heavens
that reside between the legs? It ain't death, hon,
but lack of nerve rendering you invisible. Better to be
than not to. Garb your mug in ashes. I'll revel in the divine.

"CELEBRITY" STRIPTEASE AT SOUTHERN X-POSURE

I'm no model lady, you know. A model's just an imitation of the real thing.

On stage, "Mae West" disrobes. She
slithers, writhes, addle-eyed: a girl ladled
into heels and an idol's name. "Amateur
Hour!" the bar flyer cries where men whistle,
yell as she blushes, unbosomed, the roots
of her hair like tar leaking through wheat.
What's in a name? Bared, the body's a rusted
sigil, slosh of atoms; the girl less Titian-
figured than a ghost trolling Mae's dead adages:
Ain't at anyone's mercy if I say I want it.
Money tosses among dust motes eddying
in the heat. "Do it, honey," someone bleats.
Wind shudders a torn corner of the flyer.
"You Can Be Had," it reads.

CONFESSIONAL

The only good girl to ever make history was Betsy Ross, and she had to stitch up a flag to do it.

What gal is safe from being *slut,* tether of lies that leash
a pretty girl through life? Shamed in school by those who claimed
we'd undone the captains of our football teams—
Shunned, despised, how, like dogs, we learned to heel.
How we cringed and whined, how we pissed ourselves
pretending to be good. Oh, but to insist beneath the artificial rules
a realer artifice named "I" might thrive, one capable as Mae
of jokes so bright they'd split the world to its brutal truth.
It wasn't that we were vile; we weren't sluts *enough.* Reader:
I should have taken that boy out back and fucked
the life out of him. Forget it. I've another forty years to go.
I plan to be filthy. I plan to be low. (Laugh, Reader,
so that "I" can last.) I'm writing the story of a life. Listen:
It's about a girl who lost her reputation. And never missed it.

I'm no moaning bluet, mountable
linnet, mumbling nun. I'm
tangible, I'm gin. Able to molt
in toto, to limn. I'm blame and angle, I'm
lumbago, an oblate mug gone notable,
not glum. I'm a tabu tuba mogul, I'm motile,
I'm nimble. No gab ennui, no bagel bun boat: I'm one
big megaton bolt able to bail
men out. Gluten iamb. Male bong unit.
I'm a genial bum, mental obi, genital
montage. I'm Agent Limbo, my blunt bio
an amulet, an enigma. Omit élan. Omit bingo.
Alien mangle, I'm glib lingo. Untangle me,
tangelo. But I'm no angel.

NEVER

I never loved another person the way I loved myself.

Self-Help says strong women never see themselves
defeated. They veil themselves in sateens, reheat
self-esteem with rose-wreathed validations
that never waver. Yet who doesn't thrive sometimes
on deviation, dovetail into others, see herself reviled?
For years, we stayed loyal to this self-involved idealism,
traded evasions, weathered therapy. What's a feminist
to do when every position's shelved as phony: too protean,
some say, too '70s? Mae, as nonmother, am I nervy
or self-defeatist? Am I, as you were, Nonperson?
Never stoop, Mae says, *to hyenas. I'm
a narrative, not an answer.* An evolution
of a parody she wrote that ever served her. In the end,
it was her relentless *never*s that preserved her.

PRAYER

I've been in more laps than a napkin.

Isis, Osiris: Mae's venerable kin:
raise her up, anoint nipples, lips
in pink oils, rhinestones. Name her:
Never-Mother, Moral Vermin, Minor
Porn, Vireo, Viper.
Embalm her remains in one-liners.
Preen ever in her, ever over her. Let her rise
on TV to violins: alive ever
as a hanker, a slip of spin, prism of skin
to enliven lovers, liars, to revile time.
Here's a little lay for that Never-
Has-Been, Ever-Has-Been, Nation's Stain: here's
a thin ankh beaten in tin. O Mae, O Mother, O Rival—
Ain't no sin.

ENVOI

Every mother is arrival. Ain't no sin seeking
out the *Never*s that preserve her as a tangle
in the daughter, each woman lost inside
a reputation turning her from angel
to alien, picked to pieces inside a scatter of hails.
Mae, you were an ace at stitching into armor
all our changeable faces: reveling in an image
of a self too swift to be pinned, too divine
to be anything but institution. Too cool,
too collectible, your act's become too hard
to follow. The crowd's been had by inventory:
a slip of blond, a gemmed word that swivels. *You're me,*
we say. *She's us. We're zero.* Our grave girl now, you
ever nod. Still turnip-hipped. And vague as fog.

III

Alone, I march with my ruined mouth, plaid vest
stinking of whiskey. Alone, with my little vial of pain
rattling at my leg. People want me
to say something funny and I tell them, *Only privacy*
amuses me. You want funny, break a bone
and sing through it. That's my nameplate,
calling card: fat man, drunkard, turnip-
face: rage's endless, hectoring joke.
Fans pretend they can't believe it, insist
it's all a game: they call me Santa
in the gossip pages, they call me Naughty
Chickadee. But it's the lion they like,
roaring and bleeding, their timid fists
rapping at my cage. Fame
means accepting you can be only one story.
I like to stand backstage, jeering at the coal-
scrubbed comics who won't make it, laughing
at their quivering cheeks, their still-
white mouths, and shout,
You don't believe it! The vaudeville girls,
I thought they'd get it, with their champagne
curls, breasts leoparded with sequins. But too soon
they slip offstage to wipe the grease
paint off, unpin their dresses, kiss their kids,
and let their figures go. They're tired,
they say. After all those shows. Tired women, tired
like my mother with her German cheekbones,
papery and yellow. At the stores, she could barely
rouse herself to act Camille half the time,
the other half like Garbo. While at home
she never knew what to be, wringing her hands

by the kitchen stove, too sensitive, she said,
to the sad slow beat of my heels
drumming on the carpet. She said
she wanted life to be something *realer*
for herself. Me, I can walk a mile with a nail in my boot
and a smile on my face. I can walk
until the metal drills into my sole.
I shake my vial with its jabbering pills.
I pour whiskey into my whiskey.
Then I pour it down my throat. Once while I joked
with the boys by Dempsey's locker, a group
of rotted teeth fell out. And Dempsey winced!
Tried to look away. (I'm proud to say
the space still gapes: I never got a bridge.
Why hide? That gap is me now, all the way.)
Champ, I warned the boxer, *that kind of girlishness
will get you in the end.* And then
I stuck my tongue through that bloody place
and sang "La Marseillaise."

PHILIP LARKIN'S KOAN

In the perfect universe of math it's said
the world's eternal aberration.
In fact, we should be less than dead,

math itself disrupted for matter ever to be read
as real. A thought so hard to fathom that *The Nation*
in its article on math has said

we lack the right imagination: the human head
will not subtract itself from the equation,
zero out the eager ego to be less than dead.

Did the numbers hunger for mistake, for fun upend
themselves to recalculate our infinite extinction?
And was existence meant for all, since it could be said

without our numbers others might have thrived:
the black rhinoceros, shortnose sturgeon—?
Articles of horn and scale both less and more than dead,

figurative dreams that now haunt us in our beds.
Memory's another flaw in our equation. Was it *The Nation*?
I forget. Regardless, I know that someone said
in a perfect universe, we'd all be dead.

ONCE

white field. And the dog
dashing past me
into the blank,

toward the nothing.
Or: not running
anymore but

this idea of him, still
in his gold fur, being
what I loved him for

first, so that now
on the blankets piled
in one corner

of the animal hospital
where they've brought him out
a final hour, two,

before the needle's cold
persuasions, he trembles
with what he once was: breath

and muscle puncturing
snow, sudden
stetting over the tips

of the meadow's
buried grasses after—what
was it, a rabbit?

Field mouse? Dashing
past me on my skis,
for the first time

faster, as if
he had been hiding this:
his good uses. What

a shock to watch
what you know unfold
deeper into, or out of,

itself. It is like
loving an animal:
hopeless, an extravagance

we were meant for;
startled, continually,
by the depth

of what we're willing
to feel. The tips
of the grasses high

in the white.
And the flat
light, drops of water

on the gold
coat: the red, the needle
moving in, then out,

and now the sound
of an animal
rushing past me in the snow.

SATURDAYS AT REYNOLDS WORK RELEASE

I remember never being afraid, because they said
the crimes they committed were small,
because when they locked each man alone
in the room with me—nineteen, thin as a child
beside the smallest of them—with his book
and pads of paper and sharpened pencils, only
a tiny window that looked out into the hall
where no guard stood, I could see

the boredom and the shyness on their faces, these men
fresh from prison but still waiting
in one building, in Pioneer Square, in Seattle, in winter,

where every Saturday it rained, a fact
we hardly saw ourselves but heard
in the drumming against the roof's beams and in the wet
squeak of someone's soles down the hall

where I would teach them words
they would or would not use; going over
with one man, who was twenty-five but read
as well as a fourth grader, pages of Genesis
so he could learn the terms

firmament and *plenitude;* his agate eyes
flicking over pages that looked
recently unearthed: phrases to be practiced
at his new job, which was to drive a forklift
for Weyerhaeuser, because it was the Bible

he wanted first, as another man wanted Louis
L'Amour and a third asked for the back issues of *Time*
someone left in AA on the chairs. And it was

not frightening, no, not even when one man said
he'd made tapes of letters that he would send me, recordings
of his thoughts that spooled in the dark
in the dormitory where he couldn't sleep, its locked doors

but open windows, the insomniac moon
peering in on the skinny desk clerk who checked him

in or out, who called the CO if he missed
a meeting, learning to move
from bed to work to group to lights out, but not
to outside the building to stand alone
and smoke a cigarette. And what did he feel

those nights, listening to the rain a wall away,
the cars that drove by in the dark, each steered
by someone smoking, singing, driving until morning

came with its cramped room, its yellow book to stutter over:
firmament, the men spelled out, *plenitude, gunslinger,*

working until the locked door rattled open
and I got up because it was time for me
to leave, the sounds of cafés and movie theaters
welling up behind me. So *close,*
I told them, when they got a word

less wrong, as if discipline
made a difference, stopping only when one man,
furious, slammed a hand to the table

and began crying. And even then
I wasn't scared because
I didn't have to be, listening to the thread
of the sentence he hadn't finished. *Brother,*

he'd begun, *thee shall rise again,*
while the rain spat, unseen, against our building.

OLIVE OATMAN IN TEXAS

Sherman, Texas, 1865

These blue-black lines have faded over time,
feathered into my chin like newsprint
dropped in water. And the dress
I wore for the portraits: my brother
chose its pattern: its rickrack track
at sleeves and hem, the silks
which hissed whenever I walked—

Without a mirror, I might forget
why I inspire crowds to gather: my marks

have eroded only to marks,
curlicues of smoke beside the scar
I still remember raised
along my sister Mary Ann's cheek.
Cut with a knife by a Yavapai

during our struggle, Mary Ann was the one
who bore pain without crying. *Sister,*
she soothed me as I stanched the blood,
beside all the things we've lost, what now
is a cut? She was right:

what we'd lost was greater, yet harder, too,
to imagine. The red threads webbing
our mother's eyes. And how our father stared,
unblinking, down the valley's desiccated length
in the hope of finding his family

its promised home. In truth, we'd run into trouble
long before the Yavapai attacked,
my father having prepared for our journey

poorly, so that after a week we'd eaten
through our supplies, then split the last
of our water barrels. Two of our cattle died.
And then my father himself succumbed

to those fits of weeping prayer that led us first
out into the desert, where my six siblings learned
to catch desert grouse, and I lanced the heart-
colored cactus flowers like boils

for water. Mary Ann said it was our father's burden
to lead, ours to follow: only in our suffering
would God's truth in him be revealed. What truth I know

is how we clung to each other, hearing the cries
circling our fires, watching Lorenzo,
our youngest brother, clutch a knife and claim he'd kill
any Indian who came near.

The desert night grew chill, a white sun rose, and the rest
has been written about in the papers.
But of all these things, it is my face

about which strangers wish to hear, and not
how we walked past the bodies
of our parents, our siblings—people we recognized
but had no relation to: Mary Ann and I

tied, and taken as slaves until
some passing group of Mojave, taking pity on us,
purchased our freedom. For the next eight years,

we lived with them. But why
had we let ourselves be marked
like them, why lie still for the quill
struck repeatedly into our chins, its sting
of coal smuts scrubbed into our welts?

Once I thought these filigrees
had always existed inside us, showing
the pattern from which we were made: not a new
version of ourselves but the original, as if

we, too, were composed of our father's
weakness and belief. But Mary Ann said they were signs
only of a willingness to live: we could not be
accountable for our appearance here,
she said, nor more truly

each other's sister, for now
our resemblance to each other had been made

complete. Still, when I pass the sudden
shock of a mirror, or finger the black
rise of skin on skin, I am amazed anew
at how a person can be so overwritten.

Only what we greatly love or greatly fear
makes us anyone's, and so I learned
to love and fear my liberators, especially

Aespaneo, a childless woman I called mother,
watching her try to nurse
Mary Ann through the fever I survived. Why else
should I have run upon seeing Lorenzo
years later at the soldiers' trading post?

My brother, who'd survived and grown, who'd tracked me
through news of us in the markets?
What other reaction would be natural

than flight, seeing the wild blue lights
of his eyes staring out at me from that
unfamiliar face, the long
pale hand stretched out for mine—

 Once, my father
warned me of the savagery that churns
inside the heart of nature, the sky
grown so enormous with light
it would take all our strength not to dissolve
inside it. And when I lay down

in Aespaneo's arms and felt the sweet
stinging ache of fever rush through me,
I thought I understood this wildness, the place

where God's love spreads as far
as we can imagine, though when my father's
sickness came upon him, this thinking changed.
It was God's rage, he said,
that spreads farthest, and it was fear of this

that kept him driving us out into the desert.
I shall take you to the very edge, he'd said,
*of what you can withstand, and pain
shall be your freedom.*
But when I saw the Yavapai blade

slice my sister's cheek, I understood pain
was not the edge of mastery or the requirement of freedom
but merely pain; though if pain

accompanied freedom it might have some value to it.
I would be marked, as Mary Ann had been,
and my mother and brothers, by my own hand

or someone else's. For this reason,
it was easy to lie down and let Aespaneo beard me
in the custom of her nation, as my brother
has written about for the papers, taking my portrait
in his parlor with its rugs

swirled through with chevrons, the fire
dead in his grate, the book he made of my ordeals
tucked upon a shelf. *Olive,* he tells me now,
*if you like, we can have your marks scratched out
of the negative,* but to me it makes
no difference. I confess I see only

the tight braids my brother's maid has bound
to my scalp, the wallpaper with its fists of buds,
its water stain from a summer storm that's spread
to the shape and size of a body. To the size

almost of Aespaneo, who cried the day the soldiers
came for me, saying she could not bear to lose
another daughter. I think of her

only sometimes as I run my fingers over my face, feeling
the little ridges across my chin like the scar
I traced a final time on Mary Ann's cheek. Mary Ann,
my true sister, who burned three days
to blindness with the fever from which, at the last,
neither Aespaneo nor I could save her.

ASSEMBLAGE OF RUINED PLANE PARTS, VIETNAM MILITARY MUSEUM, HANOI

My eye climbs a row of spoilers soldered
into ailerons, cracked bay doors haphazarded
into windows where every rivet bleeds
contrails of rust. An hour ago, the doctor's wand
waved across my chest and I watched blood
on a small screen get back-sucked
into my weakened heart. It's grown a hole
I have to monitor: one torn flap
shuddering an infinite ellipsis of gray stars
back and forth. *You're the writer,* the doctor said
in French. *Tell me what you see.* Easier to stand
in a courtyard full of tourists scrying shapes
from this titanic Rorschach. Here's a pump stub
shaped like a hand; something celled,
cavernously fluted as a lobster's
abdomen. How much work
it must have taken to drag these bits
out of pits of flame, from lake beds
and rice paddies, and stack them in layers:
the French planes heaped beneath
the American ones, while the Englishwoman
beside me peers into this mess
of metals, trying to isolate one image
from the rest. Ski boot buckle
or tire pump, she muses at me, fossilized
shark's jaw, clothespin, wasp's nest?
According to the camera, it's just a picture
changing with each angle, relic
turned to rib cage, chrome flesh
to animal: all the mortal details

enumerated, neutered. I watch her trace
an aluminum sheet torched across a thruster
as if wind had tossed a silk scarf
over a face. If she pulled it back, would I find
a body foreign as my own entombed
in here, a thousand dog tags
jangling in the dark? I tilt my head: the vision slides
once more past me, each plane reassembling
then breaking apart. Spikes of grief—
or is it fury?—throb across the surface.
Everything has a rip in it, a hole, a tear, the dim sounds
of something struggling to pry open
death's cracked fuselage. White sparks,
iron trails. My heart rustles
in its manila folder. How the doctor smiled
at the images I fed him: *A row of trees,* I said,
pointing at my chart. *Stone towers,*
a flock of backlit swallows—
 Now I kneel beside a cross
of blades on which the Englishwoman
tries to focus. *Do you think I'll get it*
all in the shot? she calls as she steps back.
Steps back and back. Something like a knife sheath.
Something like a saint's skull. The sky
floats past, horizon sucked into it. She won't.

IV

SHOOTING THE SKULLS:
A WARTIME DEVOTIONAL

A meditation on Andrea Modica's portraits of skulls unearthed from the Colorado Mental Health Institute

For Holly Martin

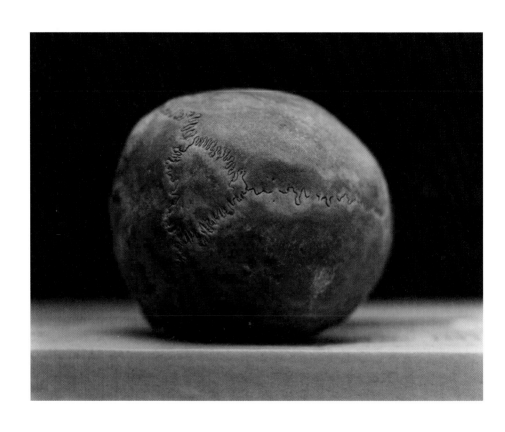

PORTRAIT OF F19: MALE, 42 YEARS OLD

What dreams remain encased inside this freckled
gourd, this ostrich egg cradled on cardboard
like the pate of a man caught catnapping on stacks
of factory cartons? My uncle, our line's humored,
grizzled hero, who'd survived Dong Re Lao
to find he couldn't work a paint-gun trigger
to spray his house planks gold and rose. Shadows
from morgue lights fissure the cracks: the skull shivers
on its paper mantel. I only think the rest
of a man's attached: crouched, fetal inside
his nightmare's flak that drifts into a mist
of candied paints. I squint, but cannot find
the hairline hasp forensics says was groined
by lobes that tried, and failed, to fuse to one join.

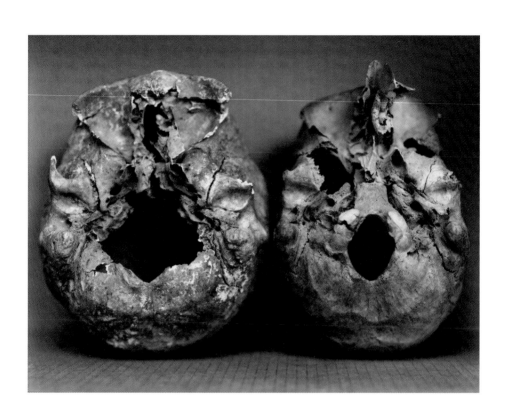

PORTRAIT OF D6: MALE, 38 YEARS OLD/ B17: MALE, 38 YEARS OLD

Propped on their brain cases, they're twins.
So why think of two boles of smoking
aluminum, or the scorched pump stubs left off
the French and US bombers a Vietnamese
artist slabheaped as a monument to Hanoi's
victories? Hanoi: the city "that should be bombed,"
as the general's said to have said, "back to the Stone Age,"
as if time itself were raw material gifted
through mechanics then taken back. Like us:
rough wires and shocks, cartilage, skin. Remnants
of men, their arms tenderly lifting out
another oil-stained engine from its carriage. More
machinery that time's ground down to parts.
We begin in beauty. What's left is form.

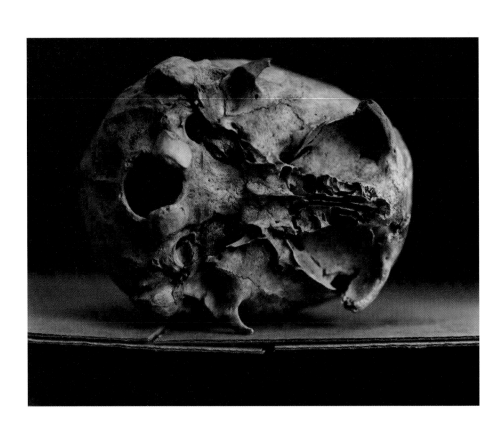

F21: MALE, 37 YEARS OLD

To you, what am I?
 A monument
in black and white, bodiless embodiment

that, like a Rorschach blot, contains
multitudes. My bone shards change

shape in mind: spread, corrupt until I'm
whatever loss you want. How could you find

out what I *was?* They buried me, diseased,
in institutions. Now newly risen, I'm made

the remains for those you think have none:
soldier, citizen: can you not palpably imagine them

except through me? Displayed, I'm gone.
My dun pate splits to show you—what? Calcium

buckshot, a cuirassed abdomen?—
atop a film box stamped "Contaminant."

No skull stays silent. Each spills its neglects:
the minds that syphilis or violence ravaged
marked by fissures the intern notes, checks
off on film for forensics to manage.
Photographs translate; bones speak. Too plainly
for a blind acquaintance who hates their feel
beneath his fingers: anonymous, strangely
blank: nothing about a face is real.
It's all skull to him. He'd rather fat's give,
a slackened muscle, some door to stand
between him and feeling, shut off what lives
beneath skin already, each bone branded
with what only death will read: skeleton key
to unlock these rooms of memory.

DEVOTIONAL

In repeats, the TV pans across a man
dragged from his spider hole in Iraq, thin cheeks
scabs of white. Before that, towers crumpled,
flamed amid a din of voices on-screen
shrieking, while a plane sheared into the Pentagon
wing where my cousin worked. Before that?
Showers of sparks launched through a green night:
desert volleys from the nuclear submarine
this same cousin commands. Now I stand
by a stranger's cranium missing
its braincase: clods of crumpled foils unearthed,
scorched papers, the thin nugget of a filling—
My eye twitches, blurs. Before I know it,
tears startle my fingers.

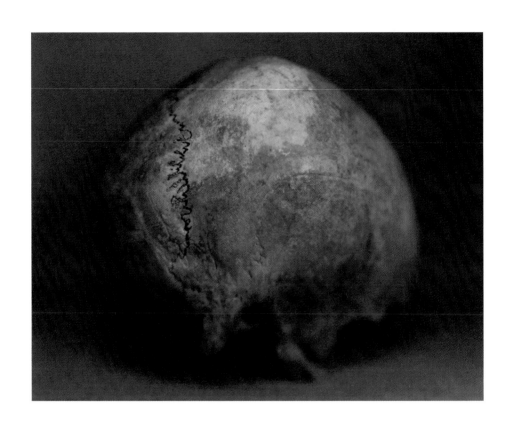

PORTRAIT OF F11: FEMALE, 39 YEARS OLD

for Lynndie England

Unhooded for its shot—a burlap sack—
this skull seems more denuded, its oval ear
canal so delicate, I long to stick
a finger there, to wiggle, poke, and hear
the lambdoid suture crack. Would this cheekbone,
if I struck it, smash? I finger grooves
where vessels plumped the skin. What fun

to imagine how my thumbs might soothe
or stop blood's flow. What sparks of pain, what groans
I'd make, the fragile joins rubbed, crushed
till a cry's released: a name, a date, a reason—

To my right, a woman lowers her head to meet it;
smiles for her phone as she snaps a pic, then shrugs:
her white fist jutting a bald thumbs-up.

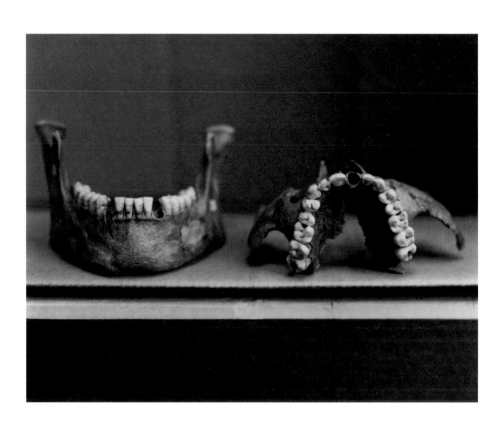

F20: MALE, 29 YEARS OLD

Only we, the mandible and maxilla, are left:
windup jaws dismantled for the joke. Stained
with tobacco and calculus, we're the fragile rest
of him that feels most human. Our size suggests his brain
was malformed, body stunted: we were his best
defense, gnashing at the hands that cuffed him,
tearing through cloth ties or plastic, leather, skin—

Fact is, you want him armed, each tooth polished
as a bullet, the hope we clamped ourselves tight
to strangers' fingers, refusing to be diminished.
That, despised, a figure of indifference,
he still had means to defend himself, some right
to wound that defined his humanness: a violence
he never lost, no matter what else he'd missed.

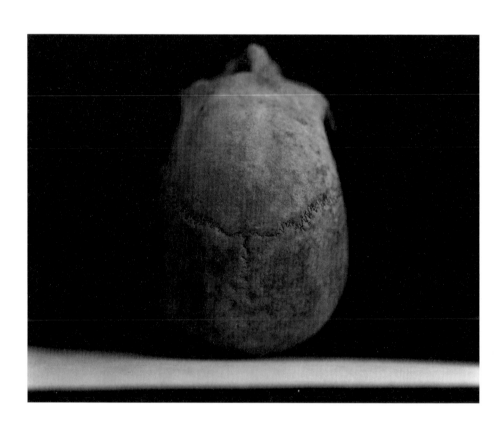

PORTRAIT OF D19: MALE, 41 YEARS OLD

This skull recalls for me *The Dying Gaul*,
that statue's cast I found secreted
in a museum stairwell, dust-veil caul
darkening the groin's slivered wound-lips.
A child, I traced that snail shape curled in its nest
of hair, wondering why a man would go to war

naked, and how his sweat-slicked flesh
might feel, slipping against another soldier's.
Easy to taste. Easy to tear. I stroked the deepest
breast folds, skin crust chipped at one thigh,
exposing a grubby notch of porcelain:
timeworn flaw for which he'd been consigned
to the shadows. The same material weakness to stone
and skin which makes me now remember him.

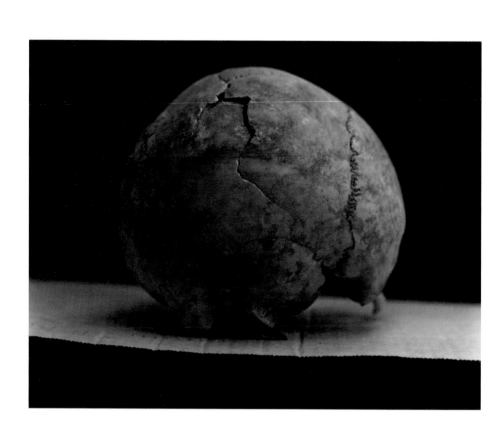

PORTRAIT OF D17: FEMALE, 37 YEARS OLD

In Phnom Penh's museum, the skulls are stacked
in aquarium tanks: grim toys for hooks to ply
free from the rubble. Here, each one gets a tag,
a mount, a photograph to suggest a life,
perhaps a name, might be envisioned. Yet I'm
more moved by what's anonymous, past; imagine
fields of faces sunken with decay, eyes
jellied in their sockets, heel meats bruised,
bloated in the rain—
 Perhaps the skulls prefer
a lack of names as, scrubbed of self and skin,
they're trauma's best witnesses: fused
by time and pain to one crisis, never
to be separated. Lost as men, they become event.
In this, they achieve a terrible transcendence.

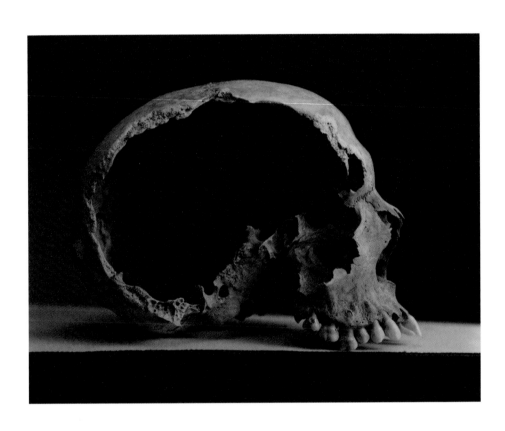

C18: male, 36 years old

Elegant as an instep, my profile's arch
sails above this smashed eye orbit, my crown
a thin moon shaving, diadem of bone: arc
under which the starless universe nestles. Eons
ago, it seems, doctors jabbered at me, prodded.
They measured my genitals and cranium, graded
my skin tone, shocked me with paddles—

Now deracinated, unfleshed, steeped in an essential
nothingness, I'm a perfect spark of blank
you still can't stand to witness, dwindled
to sex, age, quadrants as if these were my frank
embodiments: details to be controlled
or touched, wounds without which you fear
I've grown exceptional.

DEVOTIONAL

New York, April 2002

At the towers' excavated site, I follow
a student to its fenced wreckage: photos
of the missing, like stations of the cross,

backdrop to his repeated tale: the ashen crowds
he pushed among, screams of metal, a mounted cop
he watched lunge from the engulfing cloud—

Reciting his testimony to any tourist
who will listen, to inscribe himself on that silent
scaffolding—its sheared irons, erasure of rivets—

where some part of my cousin, too, resides;
his image absorbed into this makeshift shrine,
ghosting its photos. While I try and revive

a life from the rift: its bursts of steam that billow
and shroud, churning my voice to stuttered syllables.

DEVOTIONAL

What had my uncle seen in the VC's faces?
Black hair, black eyes, his high Chinese cheekbones
mirrored inside thinner cheeks: noses less
wide, yet still recognizable as his own.
Only his skin encased the claim "American."

Chinaman, the man behind me seethed
at my cousin's naval academy graduation—

Did my uncle search the enemy body
for some dying light of recognition,
or did he identify his nation through their eyes,
its rage for isolation brutal, clarified?

As now my cousin turns at the stranger's shout
to search the crowd, our camera's sodium light
of pride burning briefly in him. Going out—

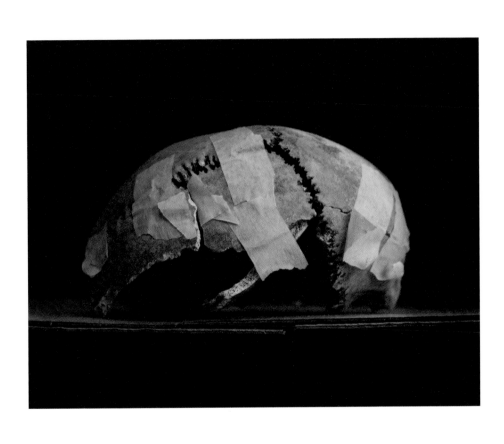

PORTRAIT OF E4: MALE, 34 YEARS OLD

Shards of a shattered hoplite helmet? Taped
platings of a Brodie? Squint, and the armadillo's
self-protective hunch appears, its stippled
skin thrice banded, flexible, the olive shell
carved like a teardrop so that its wedge head, rolled,
seals the ball. There are no chinks in its armor.
Outfitted for a fight it wouldn't start, it's victim
to its own design. I've seen boys clamor
and fishtail to hit one, emboldened by its shyness
as they potshot its plates, strafe the sides with BBs—
Why aren't all things built to repel us?
Across the cardboard, the skull shell seems
to stick out a paw; pauses, withdraws:
its split flanks creeping back to the shadows.

DEVOTIONAL

We've lost my uncle's letters from the war.
Conflict slipped if not erased from memory,
while I invent his remnants: some spore
of thought, some sheaf of papers buried
in a desk, real as these photos' ridged,
turf-pillowed half faces I watch get stacked,
ordered on a wall. They are not mine

to grieve, these lives that flared into nothing,
then too much: blunted like crumbling
incisors, cream chits that gleam with gold foil
overlays: nub winkings in loosened soils
someone's worked free and washed
of grit, parsed into a pattern that doubles
as code: consonantal messages on a bed of moss.

DEVOTIONAL

Once I caught a glimpse of him in sleep:
my cousin napping on the couch, chest spattered
with scarlets thrown down from my mother's
stained-glass windows. He lay as if beached,
tremors of shadow running his length as sun
passed behind glass so that I couldn't tell
whether he or light breathed: the legs root pale,
belly a shatter of red, blue striations
veining his clavicle. A shirt, stuffed
over the face, cut off his head. Each bit
of him I watched—the rawboned shoulder, puffed
knuckles—seemed to sink under color's scrim.
What was it that I saw? Drowned sailor, or mythic
merman? The light, or coming dark in him?

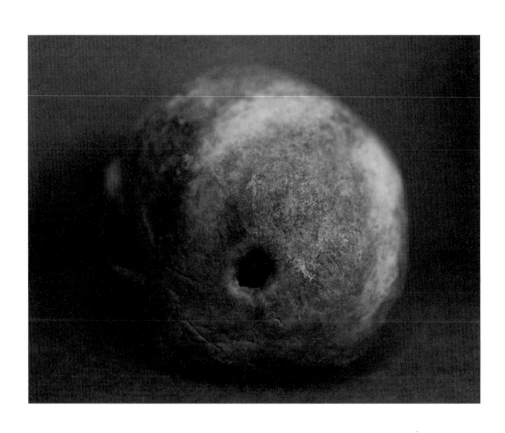

C2: MALE, 42 YEARS OLD

Why pretend my trepanation hole's
a bullet wound, nose bridge crushed by a rifle
butt? At war between your needs to uncover
and interpret, you make me emissary from a past

I had no part of, evidence for unimaginable
conflicts. Dead, I'm too public. The relic
your memory needs but cannot find: my time
underground an equal estrangement to
your family's wars. But if each of us slides behind
a mask that cannot fit, nothing comes
alive through the mix: we do not grow closer
but more anonymous—

 Look. Even my weight
in hand bewilders you. I'm the architecture
for an elegy you can only guess at.

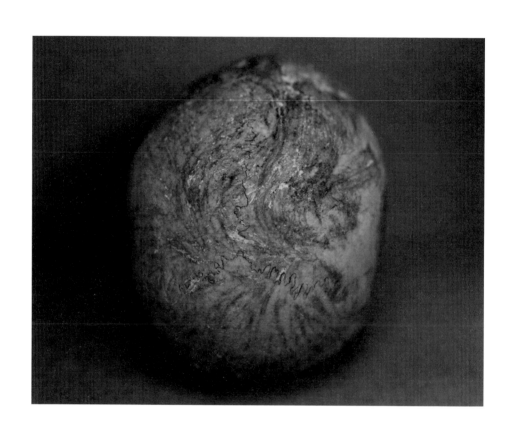

PORTRAIT OF E20: FEMALE, 32 YEARS OLD

This shot swims into sight like the sonogram
a friend has sent, her first child flickering
in the blizzard of her womb, as the cranium
on the table's grained with swirls from rotting
coffin wood. *Like fronds of kelp shuddering*
in a shale tide pool, I'd thought, but can't recall
which image sparked the phrase: child, skull: each
is an unbreachable world, as is my uncle
whose silences about his past now reach
for a history in which he's rendered
unassailable. The skull's stains curl
like a newborn's whorl of hair across a fontanel.
What dreams, inside this chamber, remain encased?
The skull, though fragile seeming, will not break.

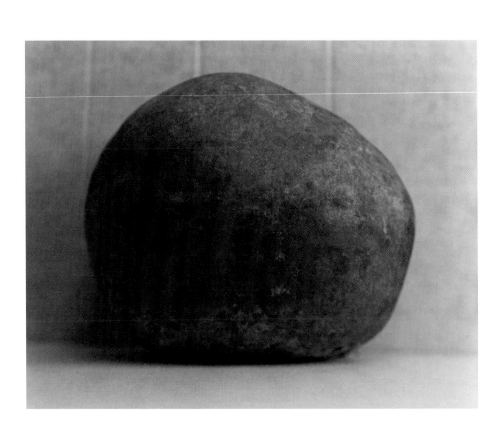

CII: FEMALE, 54 YEARS OLD

Once my throat-silts split the dark. My womb
opened, blowflies swarmed the hollow of my gut,
my pelvis flowering to a cradle of rabbitbrush.
Hills nuzzled my knees. I heard the moan
of passing cars, felt fires flame up, towers
be razed for my headstone. Had I remained, over
how much more might I reign, my shoulder cuffs
the field's parentheses, breasts pooling to freshets?
Was it envy that made you recollect me, peel off
my earthworm crown, my negligee of roots?
Your spade edge struck my slab face that time
perfected, and I was hauled up, tagged, numbered.
Rock-maw, cave of unmined amethysts, your
Helen of the Shadows. My schist hide masks my glitters.

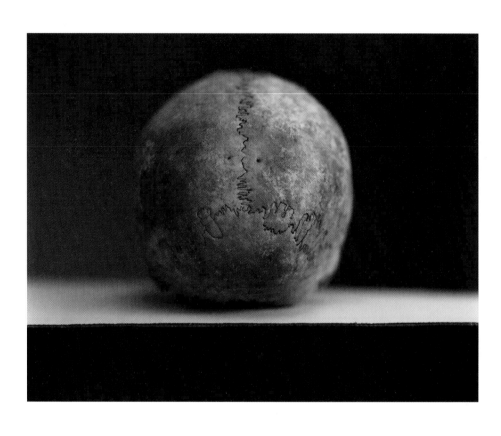

PORTRAIT OF B4: FEMALE, 34 YEARS OLD

I'd cradle this if I could, a lover's head laid
to my breast: the ossicles' seismic cursives a map
of madness—heritable grief. Our flesh-chaff's
its own elegy, monument. The cells of my cousin
circle in my blood, as some part of our uncle
slipped down with him into the cool submarine air
to peer into a target's sonar flare.

I long to put them back into the dark,
let them grow new teeth, new skin, return
to what they were or could have been. It's hurt
that moves me most in men. This one, too,
I'd slip inside: never to be woken, wounded;
to dream of nothing, as nothing more by her
must ever be borne.

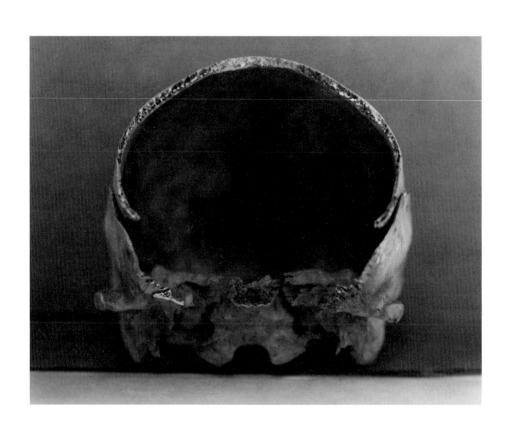

PORTRAIT OF C8: MALE, 32 YEARS OLD

Chert nubbin. Moraine of space. Cranium
honeycombed with bubbles of anemia—
So slight it seems you couldn't contain

a thing electrifying as thought. Why keep
a skull? Unless to remind ourselves of that zero
animating flesh: material evidence

we each are half a ghost. If there were a bone
for love, or fear, or pain, this calcite loam
comes closest to one. Through you, I'm drawn
deep into the emptiness that you've encased,
one more fleck of dark added to the negation

that is most truly us: what's left the face
of everything to be undone. You: gray,
freckled, weightless. Closer to me than a cousin—

V

BAUCIS AND PHILEMON

That there was a story of a girl
who changed into a tree to save herself
from love, the woman now recalls,
standing in the doorway of her guest
bedroom, staring at her son. It's Friday,
late afternoon: the time during which
their son usually appeared, hair
stuck in greasy feathers to his scalp,
leaving a trail of small and large
things missing behind him: a silver
saltshaker, a laptop tablet, so that even now
her husband's mouth hardens
whenever their son's name is mentioned.
Though it's been years since these appearances.
Their son has started up a business tutoring
high-school students, he said he's found
some sort of group, gone back to school,
and it's true they rarely see him anymore,
which is why it is so startling
to find him now asleep in the guest room
which used to be his sister's—
there are still pictures from a horse camp
framed on the wall—his black jacket neatly
folded over a chair. His white shirt
is half rolled up his stomach,
like a child's: she can see bruises
dappling his ribs and arms, and this—rather
than making her shake him awake—keeps her
peering at him, watching the thin chest
rise and fall, the sink of his stomach
like that of some starved animal,

though the more she looks, the more she thinks
it is her husband's face she sees there.
There is his slack and opened mouth, the shut eyes
that flinch in sleep. The large,
almost ugly hands are her husband's,
as are the long legs sprawled atop the sheet
embroidered with birds. For a moment,
it is her husband's death she sees
in him, and knows, suddenly, whether
out of fear or love, how much
she does not want to survive this. All those years
together guarding the boy against his moods,
depressions at school; at home, violent
outbursts against his sister. What new
erosions of his mind would they now
be witness to? And what will be
her own future, she wonders, picturing herself
and husband twined like snakes
in a field, or dissolved inside a cloud of smoke:
a thunderclap of embroidered birds.
To disappear like this together is what
she most wants, neither one left behind, alone
with their son. Unfathomable, his anger
from which she has no defense, so never confesses
the rifled car, the shed's smashed
lock, whatever trespasses only she
discovers, their son's voice on the phone
demanding to know why the two of them
have never loved him. She looks at her son's body
splayed on the coverlet. The long
and tattooed ankles. The waxy,
thin skin of his lids. *Not like you love each other,*
he'd accused her, as if it were her marriage
that had come between them, the guilt

that drove her now to leave small stacks
of cash for him to find secreted
inside a drawer. Her son lolls in sleep.
She stands and watches him till she hears a voice
calling by the door. It's her husband
home from work. He's about to mount the stairs
and find them together, and so she hurries down.
She wants to let her son sleep off
whatever he is sleeping off. To give him
time to wake, make his way into their bedroom
and find—if this is in fact what he has come for—
the newest small apology she's left him.
She wants to go for a walk, she tells her husband,
and to her relief, he's happy to oblige.
It's a clear day, not too hot in the canyon,
and as she touches his shoulder while they walk,
a mild, almost dreamy pleasure begins
to suffuse his face. Strangers,
passing by them, nod. He smiles,
she ducks her head, and they turn a corner,
their slim backs suddenly swallowed
by a stand of ever-blooming crape myrtle.

A woman and man are busy beating a tree
that has lost its blossom. The woman and man
have the tree's bare branches in hand,
they are hitting the tree to revive it, dislodging the few
small birds that have taken up residence, working
to make the lost thing once more beautiful to them.
The birds don't know: they are strange and useless,
nonsinging bodies. They open their black-ringed throats
like a swarm of coughing orators, and the sound
of their rustling is Cato dragging his silks
over the Forum's stones. Cato,
who could make an empire go to war,
whose passions became relentless enough
they turned into a project.

 Still, how wonderful it must have been
to have listened to him once: the outrage, the force
of that mouth describing the African palace
where a dead queen's shade still wept
in bed, while the soldier who loved her slipped
into his abandonment, pocketing a necklace of stones
and her palace animals' teeth.
Did he place this jewelry around his new wife's neck
in the hope of arousing a similar love?
Or did he bury it in secret, dreaming that the teeth
would turn into armies, plowing their way back
to wall up that forsaken room?

Every failed desire must be accounted for,
Cicero warned. And Cato, recalling
the soldier's shame, cried, *The foreign city must be razed!*
All those beautiful animals. They must have been trapped

in the blaze that followed. Skins crisped
or stripped by the Romans eager for a souvenir.
What would the birds, if they could,
say of the couple beating that tree?
They were young, perhaps. The man
wore a hat that looked too small for him.
The woman's dress had sweat rings around the neck.
They were not inherently cruel, but they were relentless,
and their arms, as they brought the blackened branches down
through the air, made a whistling that at first
sounded just like singing.

IRISES

How surgical the appetites
 that have cleared the deer
to its skeleton I saw lying
 in a ring of abandoned

miner's cabins: hawks
 and crows and wild dogs coming
to pick bones clean
 among the remnants,

planks of roof and ellipses of iris
 where once a garden stood.
The bones laid out like a piece of lace
 spread on a table. How carefully

the work was done: the shape
 of the deer intact, as if the object
was to make the animal
 apparent as possible. Anyone

could have seen it, the form
 from which the rest of the deer
was mere corruption. The point
 is always to get back

to this: the fine nub skull, chinks of spine
 unlocking perfectly
from each other. Any other work
 hatchetry, hunger beside it: myself

wincing at the thin
 pin bones of the fish
snapping in their silky oils.
 I wanted only to tear

one sense of use
 out of another. I have seen
so many deer: dozens,
 hundreds, but none

more vividly than this one.
 The hollow hairs
of its gray-brown muzzle, scraps
 of velvet twisting from the antlers—

I've filled in the miner's wife,
 her husband, children. Down
to where the garden
 could be found, its irises

in flames of white and purple
 someone planted, digging
into the cooling ground
 so each spring

might be realized again
 the effort it takes to make
even the possibility of ourselves
 still visible.

MONTICELLO VASE

In the Monticello I have never visited,
no two rooms sit at the same height: to walk
here is to be continually off your footing,
each room radiating out from its high
rotunda like a series of thoughts nursed
by strangers: this one with its polygraph
and whalebone walking stick; that
with its rose trellis wallpaper; one room filled
with women's portraits; another empty,
white, severe. Past the imposing
entryway with its chieftains' tomahawks
and Revolutionary campaign portraits
lie his private quarters. Here
are cabinets of French faience
and Waterford inkwells, a wine cellar full
of Madeira. In the library, someone's cropped
the painted mural of moose and mule deer
large enough to stun Buffon
had he seen them: the American animal
being more robust, as the president
once declared, than those shriveled
European creatures stunted from living
on royal grounds. Beside it a map of lands
from the Louisiana Purchase
rich enough to feed the cotton acres
his in-laws cultivated, the map itself
preserved under glass beside some lacework
made by Martha's house slave,
Critta, with which the estate
could not bear to part. Upstairs,
a red-and-white wedding-ring quilt

on the bed of Polly, his daughter,
who liked to sketch her father's face
on packets of *belles lettres,* his blunt head
faded to sepia, as has the thick hair,
once fox-red, in his hallway
Trumbull portrait. His own bedroom
contains only a globe and orrery for ornament,
a formal desk with its swiveling chair
that he invented, a dumbwaiter
installed in one corner, suggesting a mind
both ingenious and practical,
though it was this taste for hidden
spaces, chutes, and secret rooms
that has nearly hollowed out the building's
foundation. Off the kitchen—small, octagonal,
so warm it feels like entering
the heart—lies the smallest of these rooms.
It contains a single table
on which a glass vase sits. If I looked
closely at it, the faint shapes
of mangled buffalo might appear, ribs
upthrust through piles of flesh etched
into the base ring of the glass. A dozen
interlocking hooves and horns
twisted together to form great chains
of muscle, a mountain range of clashing
bodies linked together by the leg, a wolf
snapping at a man who grips him by the ears.
The vase commemorates the nation's
Corps of Discovery: the scene itself culled
from Lewis's descriptions
of an Indian jump he found the winter
before he lost his mind.
The vase's color is something between

burnt wheat and burnished copper. It has a sheen
like the painted flanks on the picture
of Jefferson's favorite horse, Caractacus:
named for the Celtic king who fought
the Romans, was taken as a slave
but spoke so eloquently he was given
his freedom. A model for Americans
to revere, the president wrote, even if they do not
remember him: symbol of native cunning
and resistance, whose power lies
in reported speeches.

BIRTHDAY POEM

It is important to remember that you will die,
lifting the fork with the sheep's brain
lovingly speared on it to the mouth: the little
piece smooth on the one side as a baby
mouse pickled in wine; on the other, blood-
plush and intestinal atop its bed of lentils.
The lentils were once picked over for stones
in the fields of India perhaps, the sun
shining into tractor blades slow moving
as the swimmer's arms that pierce,
then rise, then pierce again the cold
water of this river outside your window called
The Heart or The Breast, even, but meaning
something more than this, beyond
the crudeness of flesh, though what
is crude about flesh anyway, watching yourself
every day lose another bit of luster?
It is wrong to say one kind of beauty
replaces another. Isn't it your heart
along with its breast muscles that
has started to weaken; solace
isn't possible for every loss, or why else
should we clutch, stroke, grasp, love
the little powers we once were born with?
Perhaps the worst thing in the world
would be to live forever.
Otherwise, what would be the point
of memory, without which
we would have nothing to hurt
or placate ourselves with later?
Look. It is only getting worse

from here on out. Thank God. Otherwise
the sun on this filthy river
could never be as boring or as poignant,
the sheep's brain trembling on the fork
wouldn't seem once stung
by the tang of grass, by the call
of some body distant and beloved to it
still singing through the milk. The fork
would be only a fork, and not the cool
heft of it between your fingers, the scratch
of lemon in the lentils, onions, parsley
slick with blood; food that,
even as you lift it to your mouth,
you never thought you'd eat. And do.

MORTAL LOVE

If we were immortal, the poet said, like
the Greek gods, love
would not be needed because time
ceases to matter: love
needs urgency to be felt at all,

at which point I left the hall, hurrying
home to cook us dinner and change the sheets,
to sit a moment and rest
before you came back home to me, thinking

all the time of the gods in our stories who, even
with eternity to spare, loved,

which brought them into the human
realms of war and murder, the chaining
of lesser beings in pits of flame, the skinning
of rivals, and the creation of children

sometimes beautiful, sometimes monstrous:
the need for the shapes and skins of animals
to disguise their desires, meaning

the gods knew guilt too, and shame,
and jealousy; they knew, as we tell ourselves, about all
the human emotions in which love

is rooted: self-love and love
for spouses, daughters, sons, other
people's wives; the love for ex-
lovers too, those secret

old needs flamed out but the ashes nursed
out of respect for the failure. The gods loved

because we wanted them to be like us: no,
it is not an excess of time
that would keep them from feeling it: love
embroiders time—moving in and out of what
we imagine of it or what, if we were gods,
we could finally know.

For them, death is the thing
that is expendable; eternity means only
that suffering can be withstood
because it may be forgotten, because we are the ones
who must exist in the quick

sharpening and dulling of whatever wounds
assert us as human.

 If we are different from the gods,
it is because we are more afraid, our sweet,
dim ordinary pleasures necessary
to assuage what can't be forgotten, an instinct
where theirs is an indulgence, and so our love

is deeper, more frightening, more terrible
than theirs. The gods loved, but they loved only

as *like us* as they could. They could never match it,
they would never match it, and it is because

of all the things they loved,
eternity would teach them to covet most
their power and their will.

We have these things too, in abundance.
But not time. For love
needs no time at all.

THE HISTORY OF PAISLEY

For Shahid, who wrote this poem first: how Parvati's
footsteps rained down Zabarvan's slopes
as the goddess fled from Shiva, so enraged
her heel marks scorched teardrops
through Kashmir's valleys until paisleys

burned through every mountain glade—
Who believed that beauty outstrips
history, its violence woven through art's fragile threads
until the Scottish town that made these footsteps
famous vanished into myth, colonial shawls paid

for with blood, its guild of weavers, brawlers, poets
turned riot, shawls unraveled then lost,
the tall looms burning to a lacework of smoke—
Had he known that Europe's last
recorded witch was hung here, where once I dozed

in a Glasgow theater, startling awake
when a travel advert shrilled my name?
"Paisley on the Beach," it cried, at which I woke to see
the camera panning over sand, a flame-
haired girl turning her head at me to wink,

Paisley the name of a Scottish slum,
the ad a dig at its fallen fortunes, the name, too,
become a '70s joke. Even Shahid
laughed at it, asked if I knew
its origin and laughed again when I recited his poem:

the consort's tears, her gorgeous and immortal rage.
Now two decades later, cancer of the brain

has taken him: a fact that friends
and college colleagues mourned, arranging
at the end for me to take his vacant place.

Now I'm *Shahid's line* at work, years later,
his presence something few have known,
our admiration turned into a nickname that assumes
I'm to assume his position *and* importance: to grow
our works in one; that I might paper

over the complications of our private desires:
his to join the ranks of Faiz and Merrill, their fame
rushing mouth to mouth like a valley brushed
with fire, the whole of Kashmir become a flame
of light, a twisted tear of circling stars.

Mine to sing again of Parvati who, in my version,
doesn't run away but watches Shiva
in his sulks rush off, who wrestles him back
into her arms, the strength of her love even
greater than the god's. In my story, she is the one

who stays steady, holding the key
to her consort's brilliance that both erases
and highlights her. When I began
to recite his poem, he lobbed the phrases
back, challenged my embroidery

with flourishes of his own until the text
became some strand of sense between us twisted,
line by line unraveled to its parade of shadows,
our faces darkening as the sun began to set—
Write to me, he begged. But in what tale of exile,

love, or industry where the grieving goddess waits
for her lover to forgive then find her, tear-
marks fresh upon her face? And if I write,
will he return again to his mother, sister,
to Kashmir's lost post office, will Paisley's

weavers begin another shawl in which
we're bound, part of its ever-changing piece-
work, placed on the edge and in the center of its frame,
each slip of color throwing the rest into relief?
At first, I thought it strange coincidence

both town and pattern shared a name, but of course
industry overtook belief, gave the heady
Persian story its Glaswegian veil, overlay
upon overlay, reengraved the pattern already
extending its reaches through every border

of the world. What a strange inheritance to order:
each generation taking up then losing
the thread of the next, the pathline of one's fame
or obscurity traced through others, so that we sink
or rise together anew, the pattern's

changeability both its beauty and its flaw.
Write to me, he said. He, who for a game
slipped friends' names into poems,
submerged their stories into others till each name
became an elegy, and every name dissolved.

My name is Paisley. Your name is Paisley as well.
The softened thunder sounds its distant footsteps.
It is raining in the vales of Kashmir, Scotland, Utah.
Beloved, let us watch, and get our faces wet.
Come: let us sit together under this shawl.

"Letter from the Pribilofs": In 1879, Elizabeth Beaman, the daughter of a prominent Washington, DC, family, lived with her husband, John Warren Beaman, on the Alaskan Pribilof Islands. She wrote about her time in letters and journals that were later edited and published by her granddaughter, Betty John, in a volume titled *Libby: The Alaskan Diaries and Letters of Libby Beaman, 1879–1880.*

"Olive Oatman in Texas": Olive Oatman's story has been the account of many artworks, novels, films, and radio plays, including Oatman's own influential *The Captivity of the Oatman Girls,* which the Reverend Royal B. Stratton helped her write and publish in 1857. In 2009, Margot Mifflin published her own comprehensive biography, *The Blue Tattoo: The Life of Olive Oatman.*

"Shooting the Skulls": In 1993, hundreds of skeletons were unearthed from the grounds of the Colorado Mental Health Institute, tagged and numbered by the late forensic anthropologist Dr. J. Michael Hoffman. While little is known about the individuals interred in the grounds, several of the skulls bore marks of syphilis and were likely the remains of patients who had been abandoned or forgotten by their families. Many of the skulls were photographed by the artist Andrea Modica and published in her monograph *Human Being.*

"The History of Paisley": This poem takes its title from Agha Shahid Ali's "A History of Paisley," from his book *The Country without a Post Office.*

Paisley Rekdal is the author of a book of essays, *The Night My Mother Met Bruce Lee;* a hybrid-genre photo-text memoir that combines poetry, fiction, nonfiction, and photography titled *Intimate;* and four other books of poetry: *A Crash of Rhinos, Six Girls without Pants, The Invention of the Kaleidoscope,* and *Animal Eye,* winner of the UNT Rilke Prize. Her work has received the Amy Lowell Poetry Travelling Scholarship, a Guggenheim Fellowship, a Village Voice Writers on the Verge Award, an NEA Fellowship, and various state arts council awards. She teaches at the University of Utah and is the creator and editor of the community web history archive project *Mapping Salt Lake City.*

Lannan Literary Selections

For two decades Lannan Foundation has supported the publication and distribution of exceptional literary works. Copper Canyon Press gratefully acknowledges their support.

LANNAN LITERARY SELECTIONS 2016

Josh Bell, *Alamo Theory*

Maurice Manning, *One Man's Dark*

Paisley Rekdal, *Imaginary Vessels*

Brenda Shaughnessy, *So Much Synth*

Ocean Vuong, *Night Sky with Exit Wounds*

RECENT LANNAN LITERARY SELECTIONS FROM COPPER CANYON PRESS

James Arthur, *Charms Against Lightning*

Mark Bibbins, *They Don't Kill You Because They're Hungry, They Kill You Because They're Full*

Malachi Black, *Storm Toward Morning*

Marianne Boruch, *Cadaver, Speak*

Jericho Brown, *The New Testament*

Olena Kalytiak Davis, *The Poem She Didn't Write and Other Poems*

Michael Dickman, *Green Migraine*

Kerry James Evans, *Bangalore*

Tung-Hui Hu, *Greenhouses, Lighthouses*

Deborah Landau, *The Uses of the Body*

Sarah Lindsay, *Debt to the Bone-Eating Snotflower*

Lisa Olstein, *Little Stranger*

Camille Rankine, *Incorrect Merciful Impulses*

Roger Reeves, *King Me*

Richard Siken, *War of the Foxes*

Ed Skoog, *Rough Day*

Frank Stanford, *What About This: Collected Poems of Frank Stanford*

For a complete list of Lannan Literary Selections from Copper Canyon Press, please visit Partners on our website: www.coppercanyonpress.org

 Poetry is vital to language and living. Since 1972, Copper Canyon Press has published extraordinary poetry from around the world to engage the imaginations and intellects of readers, writers, booksellers, librarians, teachers, students, and donors.

WE ARE GRATEFUL FOR THE MAJOR SUPPORT PROVIDED BY:

THE PAUL G. ALLEN
FAMILY FOUNDATION

 amazon *literary*
partnership

 the POINT
envision · enact · evolve

 4
CULTURE

 golden
lasso

Lannan

 ART WORKS. National Endowment for the Arts
arts.gov

 A&
OFFICE OF ARTS & CULTURE
SEATTLE

 WASHINGTON STATE
ARTS COMMISSION